# EVERYONE IS CREATIVE

This page isn't blank, it's an
opportunity waiting to be filled.

Guy Armitage

# EVERYONE IS CREATIVE

7 Steps to Unlock Your Creativity

First published in Great Britain in 2023 by LOM ART, an imprint of
Michael O'Mara Books Limited
9 Lion Yard
Tremadoc Road
London SW4 7NQ

A CIP catalogue record for this book is available from the British Library.

Papers used by Michael O'Mara Books Limited are natural, recyclable products made from wood grown in sustainable forests. The manufacturing processes conform to the environmental regulations of the country of origin.

ISBN: 978-1-912785-69-8 in paperback print format

1 2 3 4 5 6 7 8 9 10
Designed by Ana Bjezancevic
Printed and bound in China
www.mombooks.com

**Yukie, Mum and Dad**

this book would have not been possible without you

**Nicki**

for being part of the journey and all the invaluable feedback
(especially on my chapter about feedback)

**To all those who dare to dream**

for making our world a more magical place

# CONTENTS

# INTRODUCTION

Yay, you opened this book! I really wanted glitter to blow out of this page to celebrate the creative journey you are about to take but bookshops have better things to do than clean up glitter! So instead, imagine millions of multicoloured particles colliding joyfully with your face. I bet your imagination will do a better job than I could have done with actual glitter.

It's safe for me to make the statement above since most of us have the ability to imagine. Yet when you start talking about creativity, people look at the ceiling and shuffle their feet.

Have you ever met a child that isn't creative? Nor have I. This means at some point in our lives something changes.

## Ever been told:

- You can't create
  (You can't draw/You can't sing . . .)
- Only some people are born creative
- You're wasting your time
- Creativity is easy
- Anyone could do that
  (when in fact you struggled with it)
- It's not a real job
- You shouldn't get paid to have fun
- There is no money in creativity
- Creativity is for the rich

Each one of these statements is likely to have chipped away at how you perceive creativity in your life. So let's start afresh.

Take a pen (preferably permanent and red), read each statement above, then **use your favourite expletive** and draw a line through the ones you've heard before (it's best to buy this book first, otherwise people in the shop might look at you funny).

# YOU ARE CREATIVE

But creativity is a process and any process can be improved. This book was written for that very purpose. It will challenge you and unleash your creative spark through simple and tangible actions.

## This book will help if you:

* Want to translate your imagination into something real
* Want to create (more and better)
* Need a creative boost
* Want to bring creativity into your business
* Are curious about the creative process
* Want to make your coffee table look edgy (but please read it at least once!)

## chapter 1

# Change is Uncomfortable

**MAKING SPACE FOR CREATIVITY**

**IN YOUR LIFE**

Does the format of this
page make you uncomfortable?
That's perfectly natural.
No one likes change.

The world is far too complex for us to reinvent how we interact with it every morning. Little things like knowing how books flow, where our TV remote is (if you have kids, did you check the freezer?) and what to expect from our day bring us enormous comfort.

Chances are, what you did today will be very similar to what you did last week, and the week before. Routines are a survival mechanism, they save us time and protect us from the unknown, but some routines can also stifle our creativity. What if you could create more by making a few changes?

The best creative projects happen at the intersection of order and chaos. Don't worry, I'm not about to ask you to give up all your worldly belongings and move to a temple in Cambodia (although it is lovely at this time of year).

This chapter explains how making small changes to how your life is structured can help you walk that tightrope and unleash your creative potential.

# SHOWER MORE

## It's nothing personal!

Our best ideas come to us when we stop thinking about solving issues and let our minds wander. If we allow our brains to lose focus and make connections between unrelated experiences then EUREKA! Inspiration strikes us.

Society seems to think that doing nothing is a waste of time. We are taught to fill every minute of our day with things to do, otherwise we're not being 'productive'. But slowing down and allowing our minds time to wander is important for generating ideas/solving problems. This is why the most mundane of places like showers, roads, duvets, toilets . . . are hotbeds of inspiration.

Some of the best storytellers I have met were part of a Bedouin tribe in the middle of the White Desert. They made space to tell stories by the campfires at night, having spent hours that day on a slow-moving camel refining their thoughts. Their lifestyles help their creativity to flourish. Our lifestyles are different and if you are permanently busy it's unlikely you're creating the right environment for ideas to grow.

You cannot plan when ideas strike you,

But you can make space for them to hit you.

## Action:

# PLAN THE UNPLANNABLE

When planning your day, give yourself an allocated amount of 'me' time; you can take this at any point in the day (30 minutes would be best but even 15 minutes could work).

Create a list of boring things you could do within those 15/30 minutes. Make sure these activities stay clear of screens.

Write them down on little pieces of paper and put them in a container on your desk (stay clear of mugs, unless you want to end up with a mouth full of soggy paper!).

During the day, if you feel you're struggling, choose a random paper out of your container and go do it (don't be put off by rain, it might actually help).

I can't guarantee you'll get new ideas each day but doing this regularly will make space for your imagination to thrive.

Oh, and don't forget to bring something to capture your ideas as you have them (ideally a notepad).

## 'Boring things' you could do:

* Walk

* Sit in a public space/outside

* People-watch

* Meditate

* Exercise (keep it light)

* Stare at a picture

* Bathe

* Drive (if it's relaxing)

* Ask yourself 'What if . . . ?'
  (Loop it)

# MAKING SPACE

# I just had the most incredible idea!

## Oh damn. It's gone.

How many times has your phone interrupted you while you were having a good idea?

Imagine everyone in your contacts and social media networks surrounding you right now, all looking directly at you and speaking to you. Mobile phones are great but inviting them into the room also invites everyone you know* in too. The last thing you want is your great-aunt shouting recipes for pickled eggs in your ear when you are trying to create.

To create effectively you'll need time to focus – and that means showing your great-aunt, and everyone else, politely to the door.

*\* Advertisers, system updates, hot matches . . .*

**Action:**

# SILENCE DIGITAL DEMONS

Show your phone who is boss and reclaim your focus with a digital exorcism.

## ☐ LEVEL 1: Choir Boy

Install an app to show you how many times you unlock your phone every day. Make it prominent so it inspires you to take action.

## ☐ LEVEL 2: Priest

Social media networks make billions of dollars selling your time to marketeers. It's in their interest to get as much of your attention as possible.

Luckily, there is an easy solution. Switch off all notifications from attention-seeking apps. You check your phone anyway, why do you need to know about something immediately? If you don't know how to, google it (e.g. 'switch off app notifications on Android').

## ☐ LEVEL 3: Bishop

Having a social media app on your phone with unread notifications is likely to make you want to go check it and then fall into an infinite vortex of cat videos (who would have known how cute they are when they wear sombrero hats?!).

Uninstalling the app completely will remove that temptation. If you need to use the service (e.g. marketing on Twitter) you can always use your browser to do so instead.

## ☐ LEVEL 4: Cardinal

This is not for the faint-hearted but why is the phone even next to you? Put your phone in a different room when you need to focus.

## ☐ GOD MODE: Pope

Focus on the social media accounts that work for you and delete all the others. This will remove that niggling feeling you might be missing out on something. The truth is you are but do you really need to know about it?

Is there anything else in the house requiring your attention? Smart watches, vacuum cleaners, beepers (not judging). Give them the same treatment. Technology only – please don't try to put children or dependents on silent!

# SLEEP

Hollywood favours a good montage of coffee-fuelled creative all-nighters in smokey rooms, coupled with an edgy soundtrack. Don't.

What looks good to you when you're sleep-deprived won't necessarily make sense once you've rested. How many things have you done when tired that needed revising the next day? So why waste time redoing things?

Tiredness can lead you to make bad decisions and lose control over your emotions. Your mind needs rest to work properly. Getting regular sleep helps you to digest information and create memories. It also clears your mind ready for the next day.

When planning your days, it's likely you'll be tempted to chip into your sleep to make time for your daily obligations. Try to sacrifice something else if possible. If there really isn't any other option, just be mindful of how you feel. If the rhythm leaves you permanently tired, give yourself an evening where you rest properly.

# THE ART OF TWO TIMING

Creative projects are the product of millions of small ideas melded together by hour upon hour of hard work.

To create efficiently you need time for **DOING**

and time for **THINKING.**

An idea without time to realize it will only ever live in your imagination and executing an idea without allowing time to refine it is likely to lead to disappointment.

'Thinking' time and 'doing' time aren't the same. We've already covered making time for thinking earlier in this chapter. But what about **doing**?

Doing is simple really – you just get on with it and do the work. Well, almost. The reality is our lives are complicated. We might have big ideas and very little time to execute them. How many times have you started something and found yourself abandoning it because it was just too hard to balance with everything else? How many ideas do you currently have on hold or frozen waiting for you?

Although I can't magic more time into your day, I am here to tell you that anything is possible with the right structure. Plan time early to fit into your current lifestyle and begin chipping at your project.

- ✱ It <u>does not</u> have to be full days
- ✱ It <u>does not</u> need to be long stints (this book was written in three-hour increments, across two years)
- ✱ It <u>does</u> need to be regular
- ✱ It <u>does</u> need to be time when you can focus and work

# PUT A RING ON IT

Committing time is the first step in making
an idea happen. This time needs to fit
with your current lifestyle, or else you'll
be setting yourself up for failure.

## I hereby commit time to create on:

**When** _____

*(e.g. Friday)*

**How long** _____

*(e.g. Three hours)*

**Until** _____

*(e.g. End of this year)*

Date _____  Signature _____

Now rip out this page and put it somewhere prominent, like on the fridge, and add these dates to your diary/calendar.

# OH NO!

YOU RIPPED A PAGE OUT OF A BOOK!

Just kidding, well done.
You just did something new that challenges you.
How did it feel?

# KEEP IT FLOWING

It's unlikely you'll finish a project in one go. Each time you leave your work and come back to it, you'll need to get back into the mindset you were previously in (a.k.a 'the zone'). Think of it as warm-up time before a race.

If you're lucky, you'll sit down and within minutes you'll be sailing along. But if you only have one hour a week to work on your project and it takes you 30 minutes to get into it, this will be frustrating.

What if I told you there was a trick to speed this up?

Ever had a smell transport you to a vivid memory? A taste bring you back to simpler times at your gran's house? A song make you uncontrollably happy? These are known as anchors.

When your brain creates a memory it doesn't do it in a vacuum, it links it to everything else that was happening around you at the same time – your frame of mind, smells, sounds, tastes. That's probably why you'll never date someone who wears the same scent as one of your grandparents.

By performing a similar task and repeating the same action (e.g. listening to the *Titanic* soundtrack each time you create), the association will get deeper until eventually, hearing it will put you in a specific mindset (thanks, Celine).

# DROP ANCHOR

Your senses never switch off. You can use that to your advantage by training your mind to return to a specific mindset quickly.

Create specific anchors for specific mindsets. Don't mix them or they will lose potency (or worse, you might put your brain into splat horror mode while writing a romance novel!).

## Things you can try:

* Listen to the same playlist when you begin work on the same project. Change soundtracks for different projects.

* Sit in the same place (same coffee shop, park bench, desk). If you perform multiple functions at the same desk, try to change the layout between them (don't do accounting in exactly the same environment where you draw).

* Make your space smell the same. Burn the same incense/scented candle when you work.

* Eat or drink the same thing before creating – but be careful not to create destructive associations (stay clear of sugar and booze).

* I've been told changing your breathing when working on specific tasks also works (but panting loudly in front of a laptop in a coffee shop isn't a good look).

* Pinch a different finger on your hand each time you want to capture an emotion you are feeling – for instance, pinch your thumb each time you are happy; after a while, pinching your thumb should make you feel happy.

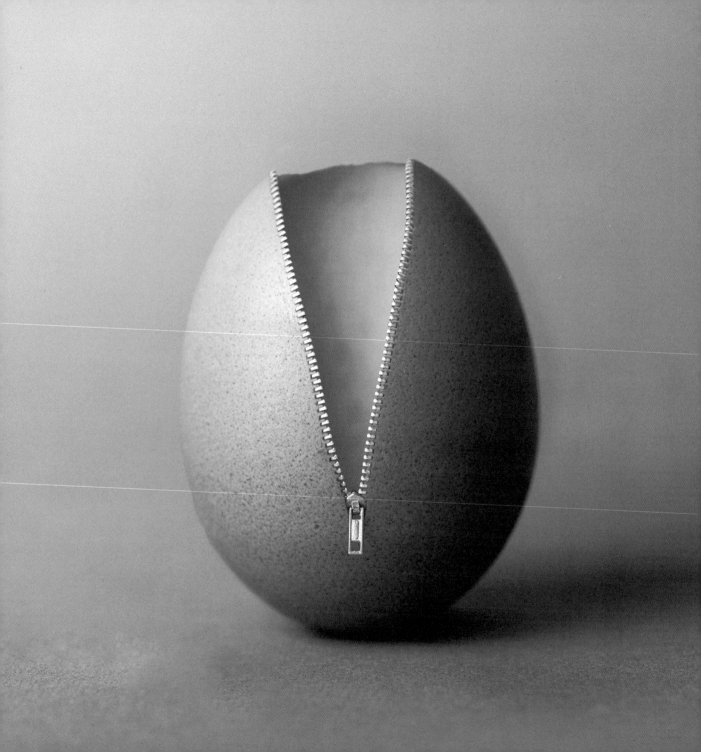

# RECAP

*1* Starting a new project will be uncomfortable at first. Make space for it and get into a rhythm to complete it.

*2* Your creativity depends on you making time to think and to do.

*3* Doing nothing will help you make space for ideas to come to you.

*4* Committing to making time for executing large ideas is pivotal in making them come to life.

*5* You can trick your mind to get in the mood faster by creating anchors.

*6* Coming up with good ideas and solutions requires you to have time in which you lose focus.

*7* Shower more.

# NOTHING
# IS
# ORIGINAL

## LEARN TO EMBRACE YOUR OWN INNATE CREATIVITY

New ideas aren't born out of thin air. Just like us, ideas evolve across generations. Every idea has parents (what inspired them) and children (ideas derived from them). But unlike us, ideas can have hundreds of parents. If you were to attempt to draw an idea's family tree it would look more like a massive bush.

Even the most ordinary objects that surround us have a rich, complex ancestry. The shade of paint gracing your wall is the product of millions of decisions built on thinking, testing and remixing (pun intended). I suspect this is especially true of the countless shades of white paint invented solely to stress-test couples discussing their new home.

Since ideas always contain some of their parents' DNA, no idea is ever completely original, it's just the child of a highly incestuous family bush (sorry).

Fixating on creating an 'original idea' is a waste of time and will lead to you getting blocked.

This chapter focuses on the concept of originality, rekindling your own unique view of the world and releasing the pressures you put on yourself.

# WEIRDLY WONDERFUL

Each time I hear 'think outside of the box', 'blue sky thinking', 'thinking different', 'thought shower', 'brainstorm', 'cerebration' (yes, unfortunately that word exists) . . . it feels like nails being dragged across a very large chalkboard.

These sayings insinuate that the way you think is not good enough and that you can change it. The truth is you cannot think in any other way. **You can only think like you.**

Thinking like you isn't just good enough, it's amazing. You were born unique and your path until now has been peppered with distinctive experiences which have moulded your way of thinking. What you might perceive as embarrassing because it is out of the ordinary can be a strength if you embrace it. Differences have led to some of the world's most celebrated works. What makes you unique, makes your work unique.

Since you are different, you don't need to think differently. You just need to think like you.

Thinking like you and finding a way to ignore how other people want you to think is a good first step to creating your best work.

# THINK INSIDE THE BOX

Banish crazy social norms and ridiculous memes
with a simple symbolic gesture.

**1** Get a large box

**2** Sit in it

**3** Think (15 minutes should
be long enough for you
to get bored and create
some good thoughts)

**4** By doing something
people don't do, you'll be
thinking outside the box,
from inside your box

## This simple action allows you to:

* Dismiss the pressure to 'be original' and focus on perceiving the world through your own eyes.

* Remind yourself that your point of view impacts how you think.

* If you feel uncomfortable doing this, ask yourself why. Explore those feelings as they might be the very same feelings that get in the way of you creating. Are you worried about how people perceive you, sitting in that box? Do you feel it's childish?

* The last time you climbed in a box you were probably a child full of imagination, so sitting in that box might reawaken some of that playfulness.

# EVERYTHING IS A REMIX

What may have started with a caveman clearing his nose on a rock could have inspired the pigment in cave painting and eventually the shade of a sunflower in Van Gogh's work. Since creativity is evolutionary, your ideas will always be based on others' work.

It's perfectly natural to be inspired by others and to let parts of that inspiration bleed into your work. It's also perfectly natural to emulate other people's work when you are learning and to permanently integrate some of their ideas into your own craft.

Remixing is a powerful tool and has been used by great artists for generations. It allows you take elements you admire and put them together into something completely new.

This being said, tread carefully. What determines whether people perceive your work as 'unique', 'an homage' or 'a cheap rip-off' is a complex cocktail of reasons listed opposite.

Being honest about where ideas come from and thanking those who inspired you will go a long way in demonstrating you are not just stealing work. Besides, once you share your work it will itself become a link in that chain. Treat those who inspired you the way you wish to be treated by those you inspire.

## Execution

A portrait of the same photo can look completely different.

## Intention

Even if a work looks extremely similar, if the purpose of its production was different it could be perceived as original (e.g. parodies/satires).

## Atomicity

Copying a large chunk of someone else's work is likely to be seen as plagiarism but taking smaller elements and mixing them with others can make your work unique.

## Audience

Your audience might perceive your work as original if they don't know what inspired it (e.g. copying an obscure style you discovered in an object in a museum in Timbuktu). However, those who do know may accuse you of cultural appropriation.

## The law

What people consider a copy and what the law considers a copy is very different. You might be ignored for borrowing a style from a famous artist but borrow four notes from a song and you could be presented with an expensive bill. Knowing some intellectual property law in your area of work is important.

# THROW ROSE PETALS

Light scented candles, throw rose petals around and get out the bear rug. Tonight, you're making a baby.

For this you will need the tools you use to create, time to focus and two or more ideas (these could be two works you admire).

Your creation need never leave the privacy of your bedroom; this will allow you to be bold and try new things out. You can choose multiple ways to conceive this child:

* Blend the subject matter of the works together.
* Recreate one idea in the style of the other.
* Take one element you really like from one and add it into the other.
* Travel these works to a different time and recreate them for that era.
* Recreate one of the works in your own style.

Experimenting allows you to develop your own unique style. If you have time, input those new works into this process again. How many cycles will it take for your output to feel truly original?

**WHAT IS THE SECRET TO CREATING SUCCESSFULLY? . . .**

# CONFIDENCE

At the start of your journey it's likely you'll feel like a fraud calling yourself a writer, illustrator, creator.

Don't.

If you are making a film, you are a filmmaker.

Focus less on the labels and more on what really matters – **how do you make a better film?**

Your work won't always be good; on occasion, it might even just feel plain bad.

That's perfectly fine.

No one gets it right the first time. You are permanently learning.

Don't let that shake your confidence. What matters is **why you are creating work**, not how one work turned out.

# EMBRACE YOUR INNER CHILD

Draw something here (best use a pencil, ink will bleed).

Ask an adult to draw something and the majority (those who are not 'professionals') will come up with a wall of excuses:

* ✱ 'I can't draw'
* ✱ 'I don't know what to draw'
* ✱ 'I don't have time'
* ✱ 'I don't have a pencil' (do you really not have a pencil or can you just not be bothered to get one?)

Did you immediately think any of the above?

Do the same exercise with a child and you'll find it hard to stop them, their drawing will often extend beyond the page onto the table and up the wall.

**Creativity is built into all of us as children.**

We're born curious, then, as hairs grow across our body, we begin to think we know everything and start caring more about how people perceive us than about who we really are. We choose to swap spontaneity for a sense of acceptance. And that's normal.

The good news is that creativity is baked into all of us at birth and although it might be covered in a thick layer of dust, it's still there. It's never too late to bring it back into our lives using the exact same tools we used as children.

# PICKING DAISIES

Children are born with no understanding of the world that surrounds them, which makes anything possible. Water can flow upwards, insects can speak and boxes are by far the greatest human invention.

As we grow, we build our own model of the universe in our heads. This forms the basis of how we will perceive the world for the rest of our lives. This incredible achievement comes from us continuously questioning what surrounds us. Children do this brilliantly (often to the point of annoyance) with two types of questions:

Harvesting knowledge
(gives depths to your practice)

Experimenting for ourselves
(evolves your practice)

Curiosity and experimentation are rocket fuel for creativity. You can make real magic happen when you daisy-chain them together. E.g.:

Why is the sky blue?
↓
What if it was black?
↓
Why do plants need the sun?
↓
What if all plants died?

Why can we not eat rocks?
↓
Why are our teeth so sensitive?
↓
What if we had diamond teeth?
↓
Would engagement rings be teeth?

A very simple question quickly leads to us rebuilding the model of the world we live in and gives rise to some fun ideas. The deeper the chain, the more original ideas become.

Let's create a few more daisy chains together. When you do so, remember:

* The answers won't just impact the contents of your work but also require you to think about your process and how you perceive the world.
* Don't overthink the next step in the chain. The importance isn't in each link but in the strange and wonderful insights you might unearth in the process.
* Make sure your daisy chains are at least ten questions long.

If you are struggling to generate ideas, start asking questions about what's around you and follow that thread.

The more curious you are,

the more creative you'll become.

# PEAK BEHIND THE CURTAI

It's very easy to get confused about what you REALLY want. Lots of people have an opinion of who you should be, and with everyone projecting highly curated versions of themselves online, it's harder than ever to find realistic role models.

* Marketing tells us to be different but wants us to buy the same thing as everyone else.
* Social media wants us to stand out but the algorithm rewards us for groupthink.
* Education teaches us to comply but expects us to generate original ideas.
* Families want the best for us but expect us to aspire to their own standards.

The biggest regret expressed by people (of all ages) before passing on is wishing they had had the courage to live a life true to themselves. Not the life others expected of them.

Being true to yourself is important and allows your work to be authentic.

Are you really doing what you want to be doing or are you doing what people expect you to be doing?

## Action:

# INVITE DEATH FOR TEA

Don't wait until the final chapter of your life to realize the book you were in was written by others. To help you reassess life, we are going to do something radical.

## Make a cup of tea.

Get a pen and paper and sit comfortably with your warm beverage. As you take your first sip, imagine the Grim Reaper appears beside you and asks you four questions. Write the answers down.

- ✱ What were you working on?
- ✱ Why were you working on that?
- ✱ Was it worth it?
- ✱ Did you achieve what you wanted in life?
  (E.g. 'I wish I had . . .')

Once you've completed the above. Are you:

* Doing what you want to do, rather than what others want you to do?
* Doing what matters to you the most right now?

If the answers to these questions were no, take a moment to think what the alternatives might be. Can you do something that gives you more satisfaction? What changes can you make so that when Grim comes knocking again you have better answers?

The prospect of dying is a potent tool in allowing us to trim things out of our lives that no longer serve us and reprioritize what matters most to us.

You may find out you are doing exactly what you need to be doing, and that's great. However, the perfect life is rare. We all have obligations that push us away from what we want, towards what we currently need. But that doesn't mean we shouldn't review our situation on occasion to see if we can improve it.

Time is the one resource you can't get back.

Spend it wisely.

# RECAP

*1*  Being true to yourself is the most potent tool in creating original work.

*2*  No idea is completely original.

*3*  Don't think differently, think like you.

*4*  Don't be afraid to be inspired by other people's work.

*5*  Curiosity is rocket fuel for creativity.

*6*  Asking 'why?' adds depth to your craft, asking 'what if?' allows you to evolve your craft.

*7*  Sitting in boxes is awkward but awkward can be creative.

*8*  Death gives life meaning; use it to understand if what you are doing today serves you best.

# HUNTING FAIRIES

## MAKING INSPIRATION

The ancient Greeks believed inspiration graced humanity via nine semi-clothed women who whispered ideas into our ears. That's a lovely image but it will leave you twiddling your thumbs waiting for the ladies to show up.

### Don't wait idly for ideas!

Inspiration is a bit of a slippery creature – if you go out looking for it directly, chances are you won't find it. Like fairies, inspiration isn't a 'thing' – the more you focus on finding it, the less likely you are to.

### You can't find inspiration, inspiration finds you.

'But Guy,'* I hear you say, 'you've just told me I can't just wait for inspiration and now you tell me I can't actively find it!'

You are right, it sounds contradictory. Think of it as creating a bird sanctuary in your garden. You can't force birds to come and stay but you can put up a birdhouse, provide some seeds, plant trees . . . If you create the right environment, the birds will eventually grace you with their presence. Just like our feathered friends, inspiration will arrive once you've created an environment for it.

This chapter explores ways you can make your imagination flourish.

* It's pronounced 'Ghee'. Yeah, I know, strange but French (well, Swiss).

# CRAP IN, CRAP OUT

Ideas don't just hit you; they brew inside of you, feeding on the experiences you have collected.

Your body cannot function at its best without a balanced diet and your mind is no different. Eat only ice cream and you'll likely need to get the mop and bucket out. If you give your mind only one type of stimulus, what it regurgitates is likely going to need to be cleaned up and binned.

Everything that you consume across your life informs your ability to create. It provides your mind with the fertile soil in which it grows new concepts. If your experiences are always the same, your imagination will feel stale and flatline.

Diversifying the types of experiences you collect will give you a deeper pool of inspiration to reach into and help digest what you've already consumed.

**Action:**

# EAT YOUR BROCCOLI

Understanding what you currently do will allow you to quickly identify what is missing from your mind's diet.

Take a few minutes at the end of each day to map out all the activities you've done which took more than 30 minutes.

At the end of the week, take a look through your lists and check for patterns. What do you do the most? Could you swap a couple of hours of Netflix for a book? Are you always eating the same thing? Could you swap Dave for Diana? Is there something you really want to do that's missing from your lists?

You don't need to change your habits completely to invite inspiration. Tweaking them slightly could bring a breath of fresh ideas into your life.

Your daily list should look a little like this:

| WHAT | NOTE | DURATION |
|------|------|----------|
| Sleep | Interrupted by baby | 7 hours |
| Work | Writing article | 3 hours |
| Work | Emails | 1 hour |
| Eating | Ham sandwich | 30 minutes |
| Work | Coding | 6 hours |
| Eating | Pizza and broccoli with Dave | 30 minutes |
| TV | Watch the last episode of a popular drama show | 2 hours |
| Social | Angrily posting on social media after finishing the popular drama show | 1 hour |
| Chores | Cleaning up | 1 hour |

# (UN) GROUP THINK

The internet is amazing, it captures the world's consciousness and makes it available to us at the touch of a few buttons. But click on a couple of cat photos and soon your feed will be littered with pictures of Sphynx cats in woolly jumpers. (Google it – oh, wait, don't.)

Enjoying a good cat gif isn't a problem. The problem is that the algorithms that serve us content remove alternative ideas. When these differing points of view are missing in your life, you may ask if they even exist. With so many cats, where are the badgers? Weasels? Pigmy shrews?!

Swap the animals in the statement above with political views, philosophical thoughts, ethical positions, alternative lifestyles . . .

How can you discover something new when what you are presented with is a reflection of your own thoughts?

The internet is rich with inspiration; you just need to learn how to punk the algorithms that run it.

## Action:

## CRACK THE SILO

Passively scrolling through your feeds will only ever show you what's popular or matches your interests.

To mix things up, you will need to actively look for different sorts of content. An easy way is to regularly identify interesting people you wouldn't usually engage with and follow them. This could be based on any of the following: age/race/gender/religion/political views/interests/location . . .

You can search for them directly on the social media network (in the understanding that the algorithms will be listening and serving accounts it feels you will like). Or, to circumnavigate the algorithms, go looking for them using your favourite search engine. E.g. search for:

* 10 female black writers you should read
* 10 Egyptian entrepreneurs changing the world now
* 10 LGBTQ+ filmmakers on the rise
* 10 war veterans to follow on Twitter
* 10 new Japanese artists to follow on Instagram

The more diverse the accounts you follow, the more likely you will bring new thoughts into your creative process.

# BOTTLE IT UP

## Being alive is beautiful and messy.

Like pigment in art, our emotional range gives depth to the works we create and shouldn't be wasted. Every experience, no matter how positive or negative, is equally valuable in the pursuit of inspiration. Our ability to feel ecstasy is linked to being able to feel melancholy. Neuter one and the other will follow.

Next time you face an extreme emotion, try to make a mental note of it – recognize it and instead of bottling it up, put it on the mantelpiece so you can access it later.

Using it when you create will give your work meaning and it may also allow you to come to terms with these complex moments in your life. The more you paint with the same pigment, the sooner it will run out.

# OFF YOU GO

This morning, you probably woke up in your bed,* travelled the same roads at the same time and you might even be about to have the same lunch. It's efficient but it's unlikely to make you feel inspired.

Travelling to countries that are radically different to yours and spending time with the locals will certainly put fresh ideas into your head. The more extreme the change in your environment, the more enriching the experiences will be.

However, swapping your bed for the floor of a Swahili tribe's hut or a pod hotel in the centre of Tokyo poses a few issues:

* Relinquishing control and living in the moment in an alien land can feel scary.
* Travelling far away can be eye-wateringly expensive.
* Accessibility might be challenging in a new location.
* You may not want to grow your $CO_2$ footprint.

Luckily, travelling doesn't need to be extreme – even new places near you will help unlock your imagination.

*\* You didn't? Good for you (I hope they made you breakfast!).*

# GET LOST!

Going somewhere new doesn't necessarily mean the other side of the world. New experiences can be gathered just outside your front door. Exploring your surrounding area is a wonderful way to pepper your routine with fresh experiences.

If you like sitting on a bench and people-watching, choosing a different bench could be enough to give you access to different experiences (different demographics in different places).

Opposite you will find a 'map'. Your mission is to take some time to visit every segment on it.*

Take your time to get to the locations you're exploring – walking is ideal so you can take it all in. Once you get to the segment, look around, have a coffee, walk into public buildings, start a conversation with someone (I know, right?!).

When you return, colour in the segment and plan a date for your next outing.

*\* If a segment is unsafe, skip it! I don't want you walking into an ocean.*

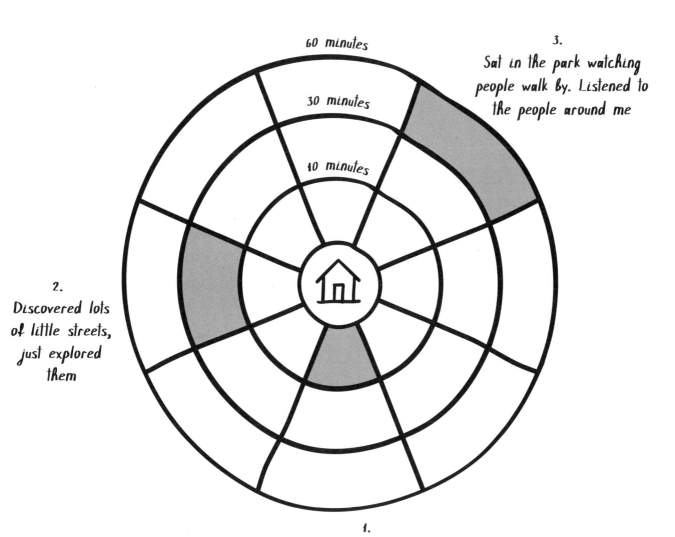

60 minutes

30 minutes

10 minutes

3.
Sat in the park watching
people walk by. Listened to
the people around me

2.
Discovered lots
of little streets,
just explored
them

1.
Found a new cafe, had a conversation
with the table next to me

# SIT DOWN, GET UNCOMFORTABLE

The human urge to belong to a group is as old as history itself.

Early in life, these groups are restricted by our physical location. Starting with our families, expanding into schools, hobby groups, universities, workplaces, they also include the brands we choose to associate ourselves with (so, I'm a PC guy*) and the billions of people in the digital realm who we could potentially have a conversation with (*cough* – swipe right on).

As we build our tribes, we gravitate towards like-minded individuals who make us feel valued and safe. But being surrounded by people you agree with is less likely to teach you something new.

Do you find yourself agreeing with everything that is being said around you? Have you heard it all before in some format or another? It's time for a change.

*\* How did that make you feel? And why does it matter?*

# POKE THE HORNETS' NEST

We often discuss the same topics with the same people in the same places. This keeps us safe from things that may challenge us or make us feel uncomfortable, but it also stifles discovery.

It doesn't take much to create more value in the conversations you are having. You can build an interesting conversation by randomly choosing a topic, a person and a place and going for a chat. The magic happens when these three elements don't match the usual routine.

## Step 1

Pick a topic, a person and a place.

| | TOPIC<br>Something you … | PERSON<br>Someone who … | PLACE<br>Somewhere … |
|---|---|---|---|
| **SAFE** | … want to know more about<br>… know nothing about<br>… don't understand | … knows you well<br>… knows the subject<br>… is usually quiet | … you both know<br>… you know<br>… they know |
| **DARING** | … strongly believe in<br>… strongly disagree with | … you've just met<br>… disagrees with you | … unknown to both |

## Step 2

Have a good conversation (without judgement). Try to ask at least seven questions to give it time to develop.

# RECAP

*1* You can't make imagination but you can create an environment in which imagination can thrive.

*2* Diverse experiences fuel your imagination.

*3* You need to actively seek out new ideas in the digital world to help on your journey of discovery.

*4* Strong emotions should not be wasted. Don't bottle them up, acknowledge them to inform your work.

*5* Visiting new places can help you unlock new ideas – and best of all, you don't need to go far!

*6* Uncomfortable conversations are worth gold if we are willing to learn from them.

# chapter 4

# CREATE, DESTROY, REPEAT

## EVOLVING YOUR WORK AND OVERCOMING COMMON CHALLENGES

Many of your creations won't make the cut, many ideas will fail and that's **perfectly fine**.

The first thing we create is never going to be ~~prefect~~ perfect and neither will the second, third . . . I'm on version ~~57~~ 161 of this book and it still won't feel completed by the time you read these lines.

Seeking perfection is a lot of pressure and could lead to you wasting valuable time on that final brush stroke.

This chapter covers how to increase your rate of success, what to do about 'perfection' and how to deal with 'failure'.

# FAIL FAST

Starting out on a project you really care about is likely to put a lot of pressure on you as you do your best to get it just right. This is especially true if your process is irreversible. I can't imagine how many marble genitals were wasted due to a slippery chisel.

Instead of jumping into a large project thinking it will birth a masterpiece, create smaller-scale experiments to test ideas. If you are happy with the results, scale up your ambition and create a larger test.

Delving into smaller tests means you can get feedback quicker and improve your work faster. This doesn't mean you should limit your ambitions (by all means, think really big!). Instead, experiments allow you to increase the speed of your progress. These experiments may one day lead to a masterpiece. This will be the result of thousands of micro experiments that have honed your skills and refined your ideas to a point where your work is worthy of recognition.

# PRACTICE PERFECTS

This exercise is simple – you'll be redoing the same micro project seven times across seven days. Give yourself a maximum of an hour for each sitting. You can modify the amount of time to be more suitable to your craft, but it should be considered a small amount of time for your practice (a sketch can be done in five minutes but writing a song will take longer).

The repetition and short timelines remove the pressure you place on yourself to create perfection.

**Practice may not always make perfect**

**But it certainly perfects.**

Creating quick work doesn't mean the topic should not be interesting. For that very reason, I've picked a universal theme. Something that has gripped people's hearts for centuries. A theme so potent it is bound to get your creative juices flowing.

Create seven micro projects featuring . . .

a sausage

(it can be vegan)

Once you complete a session being creative with your sausage, put the results away until the seven projects are complete. When your seventh session is over, take all your sausages out, put them side by side and compare the evolution of your work. Did it improve? How did it improve? What did you learn? Was the last one the best? Could you ask someone to put them in order of best to worst?

Keep your favourite and least favourite sausage masterpieces to refer back to. You could make them visible from your workspace to remind yourself of the importance of evolving your work.

This exercise could be integrated into a warm-up routine; just pick an equally irreverent topic (any object should do) and off you go.

# NEVER ~~WAIST~~ WASTE A GOOD FAILURE

How many times did you faceplant into furniture learning how to walk, redecorate the walls trying to navigate a spoon into your mouth, give the most unsatisfying kiss and crash the stock exchange (OK, that was only once but yeah…). The most basic things you are an expert in today are the by-product of countless failures.

Failure is natural if you are doing something completely new. Since creativity is all about exploring the unknown, failure is unavoidable, full stop.

**If you are not failing, you are not growing.**

**If you are not growing, you are failing.**

The best thing we can do is figure out how to dust ourselves off quickly, learn from the failure and move on. The faster we go through this process, the less impact the failure will have on our wider craft.

## SHARPEN YOUR SCALPEL

Let's play a game.

1. Draw three columns on a piece of paper with the following titles – **Ideas**, **Learnings** and **Incinerate**.

2. Get out your most notable recent creative failure. We're going to take it apart to see if anything can be salvaged.

3. Are there any **elements that can be reused** for future projects? Note them down **in the Ideas column**.

4. What **valuable lessons** did you learn from your failure? What made it fail and **how would you do things better** next time? Note those down **in the Learnings** column.

5. Write down any **regrets** you might have due to the failure, or **anything out of your control** that led to the failure **in the Incinerate column**.

Once you've extracted all the value out of the failure, rip the Incinerate section of the page off and ceremoniously bin it (recycle it). If the failure feels close to you, you may want to make a thing of it – shred it, give it a Viking funeral . . . Once that's done, move on. You can repeat the process for any failure you wish to visit.

It might be worth transferring any Ideas and Learnings to notebooks for safekeeping. When you start new projects you can refresh your mind and maximize future success. If you pay attention, you may see patterns in previous failures, so make sure to avoid those in future projects.

# RIP EGO

Success seems to come easily to those around us. Our social media feeds are constantly bloated with the echoes of everyone else's achievements.

**Ignore them.**

Anything shared online can show even the smallest milestones as tremendous achievements (some people may even go as far as manufacturing their own successes in the hope of kick-starting them).

Almost no one celebrates the hard parts of the creative process publicly. Those gruelling hours practising over and over again. These moments, missing from our feeds and trivialized by the media, are the essence of your success. Even if you don't see them celebrated, they are normal.

**You're doing fine. Keep going.**

**Overnight success takes a decade.**

# SIDESTEP THE BLOCK

Try really hard not to think of a monkey juggling jelly.

*Really, don't think of that monkey.*

Yeah, you can't.

That's exactly how a creative block happens. The harder you try not to think about being blocked, the more blocked you become, leaving no space in your mind to create. The same applies to trying really hard to find fresh ideas: your mind will focus on the concept of creating an idea instead of actually creating an idea.

The only way to move out of the block is to present your mind with something completely different (reading the last paragraph allowed you to forget that monkey – although I bet it's back with you now, wobbly jelly and all).

When you find yourself blocked, you can't just trick your mind into ignoring the issue (since the focus will still be the issue). Your cure is to walk away.

## SQUAWK!

When you are blocked you need to do something radically different. The bigger the block, the more radical you need to be.

Next time you are blocked, do the action opposite based on today's date (you might want to close your curtains first).

If you are unable to do any of the listed activities, create your own. Make sure they require you to focus completely on a problem that isn't related to your craft.

How long you do the activity for will depend on how bad your block is. If you are really blocked, you might consider referring to the **Plan the Unplannable** chapter instead (page 16).

| TODAY'S DATE ENDS IN A | ACTION |
|---|---|
| **0** OR **5** | Lie down on the floor looking upwards. Take deep breaths and as you breathe out, imagine you are blowing out a string of gold dust that aims to hit the ceiling (if you can't lie down, aim for the closest wall). |
| **1** OR **6** | Extend your arms out at your sides and practise making the perfect wave, starting with one hand rolling across your shoulders to your other hand, then back again. |
| **2** OR **7** | Practise winking with one eye and then the other. Try to keep your cheeks still and speed it up. |
| **3** OR **8** | With the tip of your tongue, try to touch the left and right edges of your mouth, followed by the top and bottom of your lips. Repeat ad nauseam as accurately and as fast as possible. |
| **4** OR **9** | Stand up and roll an invisible hula-hoop – ten times one way, then ten times in the other. Make your move as smooth as possible. If you have a hoop, use that. |

If today is the **21st** jump around your house on one leg and squawk like a flamingo (or pick your animal of choice. NO SLOTHS!).

# BLOW THE DAM

Some say perfection is unattainable; I disagree. But perfection is fluid. Your work may be perfect for a fleeting moment to some people but they may not feel this way the next time they experience it.

You can't achieve perfection for everyone, all the time.

You can only achieve perfection for someone some of the time.

How you perceive your work is no different; it may be perfect one day and you may hate it another.

Choosing perfection as the goal makes the odds of failure much too high. It slows you down and may even stop you in your tracks (analysis paralysis). If what you are working on today is better than what you did yesterday, you are succeeding in your journey to eventually creating something incredible.

Instead of seeking perfection, aim to continuously improve your work, accept that perfection is fleeting and nothing will ever feel finis . . .

## Action:

# A TRICKLE INTO A FLOOD

Have you had any of the following types of ideas?
(Take a few minutes to really think about them.)

* An idea so big it terrifies me
* An idea I'm not sure will work
* Something I keep telling people I will do and never do
* Something I am working on that's taking a long time

We will take one of these ideas and get it out of your head, but there is one caveat – you need to **start from scratch** and **do it in one sitting**. The length of that sitting is up to you (it could be an hour, or eight). If you block or take longer than 15 minutes off, that's it – your time is over.

Don't plan, don't review, don't edit. Just create until you can't anymore. Having a strict time restriction will force you to move away from achieving perfection.

Over time, these sessions will help build depth to the projects you wish to undertake until what seemed insurmountable feels doable.

# RECAP

**1** Perfection is a moving target. If it is achieved, it will only be for a moment.

**2** Getting stuck is the worst possible scenario, try to keep the momentum.

**3** If you are blocked do something radically different.

**4** A failure is only a failure if you don't learn anything from it.

**5** Sausages are really inspirational.

**6** Doing nothing because you are scared of failing is a failure.

**7** Nothing of worth comes easily. Practise, practise, practise . . . you'll get there eventually.

**8** If your craft improves a little each day, you are succeeding.

# BOTTLING THE UNIVERSE

GET STARTED AND PLAN

YOUR CREATIVE PROJECT

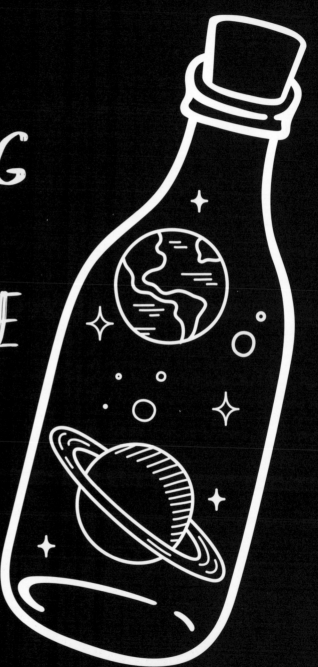

Ideas are wonderful. They allow us to live alternative lives, remodel the world we live in, challenge it, escape it. Releasing them is the most potent tool in bringing about change and allowing others to see the world differently.

However, your imagination belongs to you and only you. No one can take it from you but no one can ever share it.

Without action, your ideas will forever live in the moist space between your ears.

Action is what differentiates you being imaginative to you being creative.

This chapter covers deciding which ideas to focus on and how to bring them to life, with a little forward planning.

# PRESSING PLAY

Ever found yourself looping through Netflix without being able to make a decision? Too many choices can lead to navigating from option to option forever without ever clicking play.

There's a reason that happens. Having two options means comparing one to the other (one choice), having three options leads to three choices (comparing one and two, one and three and two and three). Netflix has 6,821 shows. If you were to compare them all to each other before making a decision it would take you four years* browsing the menu before watching anything (23 million+ combinations).

**The time it takes you to make a decision increases dramatically for each additional option you have in front of you.**

Running out of ideas isn't great but having too many is just as problematic. Too many creative ideas can get in the way of any of them coming to life. When planning what you want to do next, remove as many as possible to allow you to make faster decisions.

*If it took five seconds per comparison and you gave up sleeping.*

# LINE UP YOUR DUCKS

Have too many big ideas sloshing about in your head? Let's make space.

1. Clear a table, or use a blank wall.

2. Partition your surface into four columns (use tape if that helps).

3. From left to right, label your columns Now, Later, Much Later and Never.

4. List the ideas you want to do on individual Post-its.

5. Place your Post-its in the column that best describes when you want to do them.

6. Move your ideas around until you have a maximum of two in the Now column.

7. Focus your time on the ideas in the Now column. Forget about the others for now.

Once you have more time available, revisit this chart, add new ideas and move the projects around until you identify the next one to focus on.

# WANDERING THE WOODS

Taking a walk in the woods without having a destination is likely to get you lost. Your creative work is no different. Every creative project you undertake is a chapter in the book that is your life. If you get lost and a chapter becomes too long, you'll have less space to develop your story in future chapters.

**Doing something without knowing where you are going could lead to you working on the same thing forever.**

Ideally, every project you undertake should have a purpose (an end to aspire to); however, if you are just exploring ideas then be sure to set a time frame for your exploration. By all means **go and get lost in the woods**, but be back before sunset!

## IDENTIFY YOUR NORTH STAR

Knowing why you create is vital to being able to progress towards your goal. It will help you make the right decisions on what you should do next.

On a piece of paper write the answer to the following question.

## Why do I create?

Think of the following:

* ✱ Career choice or a hobby?
* ✱ Does your happiness depend on you creating?
* ✱ Are you attracted by fame and/or fortune?
* ✱ Does your creativity depend on a story you wish to tell?
* ✱ Or something else altogether . . .

## Be ruthlessly honest.

This is about what YOU want. Being honest will allow you to make the right decisions. Next time you start a project be sure it is compatible with what you've written! (E.g. if you need money, focus on the payout.)

# RECALCULATING

No matter how much you plan, things will change. That's just life: some things you control, others you don't. Blindly following a plan you put together at the start of your journey might lead to you ignoring valuable lessons learned along the way which could ease your progress.

## Don't just stubbornly follow the set path.

Know your destination, mark that X on the map, but be sure to stop every now and then to review your journey.

* Is there a faster route?
* Could that destination be approached differently?
* Has the 'weather' changed and should you delay your journey for now until the weather clears?
* Would involving others at this point help?

Being agile is key in overcoming any obstacles that might show up on your creative journey. If now isn't the right time, don't risk wasting your resources – store them away and take them out when the weather lifts.

# STRIP DOWN

Picking the project you do next depends heavily on the resources you have access to. But breaking down the resources required for all your ideas in order to compare them could take months. Besides, knowing exactly what you need at the start of a project can be challenging.

When things get too complex, strip them down to their bare essentials.

At its most basic, any project will require:

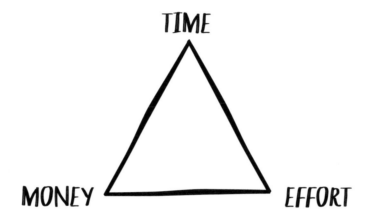

To make anything happen, you need at least two of these. Without money, you'll need to put in more time and effort. Without time, you'll need to pay someone else to do it for you and put in more effort to get things done in the limited time you have.

The alternative could be to reduce the ambition for your project if resources are scarce (a 20-metre canvas could be 10 metres, a film could be set in a single location) . . . or you could spend time to raise resources (which is a project in itself).

## Action:

# STACK YOUR CHIPS

Understanding how complex a project might be is invaluable in your planning process. You can compare a project to another quickly by doing the following.

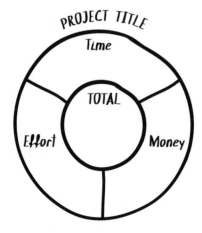

**1** Create a circle like the one on the right for each project you want to compare. Name them.

**2** Think about what you will need for each project. Fill out the time, effort and money segments with a number between one and nine. (One is a small amount and nine is huge.)

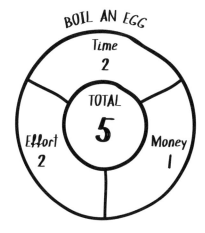

BOIL AN EGG

**3** Add the numbers together and write the total in the centre of the circle. This will give you the scope of the project (how complex it will be).

**4** Fill out a circle for all the projects you wish to compare.

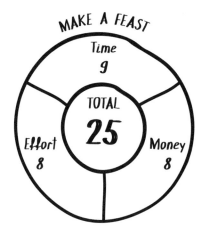

MAKE A FEAST

**5** Compare the totals of each project to help you decide which project to undertake next. The lower the total number, the simpler the project.

If a specific resource is scarce (e.g. if time is tight now), you can focus on that segment only to help you plan.

# EMBRACE BREAKDOWN

**The impossible is achieved by people like you and I.**

But the impossible takes time, grit and determination. Twenty years for the Great Pyramids of Giza (and 20,000 labourers), six years for the first Harry Potter (rejected twelve times by publishers) and four years for the ceiling of the Sistine Chapel (permanently damaging Michelangelo's eyesight).

If you undertake a large project and focus solely on completion you will run out of steam quickly. Going to bed knowing your work will take another four years is hardly going to motivate you. Instead, when your head hits the pillow, celebrate what you've achieved today.

**Feeling like you are making progress is essential in allowing you to stay motivated and complete larger projects.**

Breaking things down into smaller chunks allows you to mark things as done and maintain your momentum.

# RAISE THE DEAD(LINES)

Breaking your work down into one mega to-do list gives you an idea of what needs to be done, but it might put you off. To stay motivated, create another list and add everything you would like to achieve during the next two weeks. No task should take more than a couple of days; if it does, break it down into smaller ones.

Strike tasks off it as you go. Once the two weeks are over, review your progress, move anything that wasn't completed back into the master to-do list and plan the next two weeks.

Each task you complete brings you own step closer to your goal.

In the next two weeks I will:          End date: _____

1. ~~Research the mating rituals of penguins~~
2. Apply my learnings to chapter 8
3. Plan chapter 9 (bullet points)

# RECAP

**1** Action is what separates imagination from creativity.

**2** A minimal amount of planning can radically help the success of your project.

**3** Resources spent on one project cannot be spent on another. Be strategic on which project you undertake next.

**4** Things never go according to plan. Have a destination but don't hesitate to review how you will get there should things change.

**5** Having too many ideas isn't always good. Try to focus on just a few to get things done.

**6** Keep momentum by breaking down what needs to be done into two-week segments.

**7** The bigger the ambition, the more grit and determination you'll need.

# THE
# RIGHT
# KIND OF
# FLASHING

# HOW TO SEEK FEEDBACK EFFECTIVELY

Our work often feels like an extension of ourselves and showing it to others can make us vulnerable.

Getting feedback on something you've spent months crafting is like finding yourself nude in front of a group of strangers (we've all had that dream . . . right?). But sharing your work is pivotal in gathering insights early and improving your craft.

**Sharing may never become easy but it will always be worth it.**

This chapter covers a few tricks to gather the best possible feedback and what to do with it once you have it.

# THE CHOSEN ONES

Some people will praise your work no matter what,* some won't understand it,** others will automatically criticize it, or worse still – be too busy to care.

Your relationship with who you share your work with informs the type of feedback you get from them.

Deciding when and with whom you share your work allows you to build a balance of confidence and critical feedback to help carry you through projects and increase their impact.

*Thanks, Gran!*
*** Thanks, Gran!*

# SINK BATTLESHIPS

Check what type of feedback you are getting currently.

Make a list of three actions:
1. Copy the chart below to an A4 page
2. Think of the people you share your work with the most
3. Map them to a specific quadrant

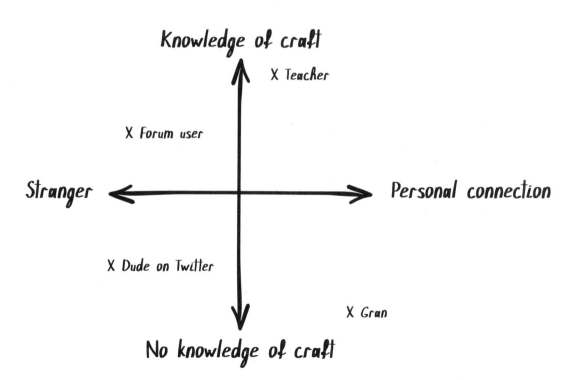

This is the type of feedback you are likely to get from the people you mapped in the specific quadrants.

## Validation

The most honest, informed opinion you'll get. Keep the ask small, without a personal connection this group may not invest much time in you.

## Early feedback

The best feedback to evolve your work. However, some people may not speak hard truths to protect your feelings. Keep those willing to be honest and move the others to Ego boost.

## Test audience

Understand who is most likely to engage with your completed work. Seek feedback from this cohort at the idea stage, or when your work is complete.

## Ego boost

Having doubts? Experiencing impostor syndrome? These people will carry you through these moments. But don't depend on them for unbiased feedback.

Next time you approach anyone, think about the purpose behind you sharing your work with them. If that's what you need right now then go for it. If not, refer to the correct quadrant and pick someone else.

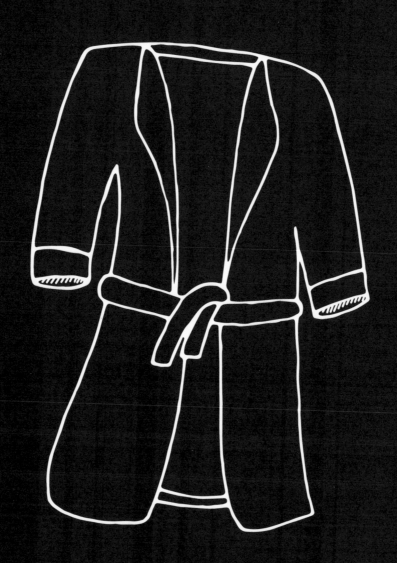

# DROP THE ROBE

You pull the cloth off your latest creation; a rapture of jubilation and clapping fills the space. People shower you with flowers, kisses and underwear (clean, hopefully). After years working alone, the feeling of happiness overwhelms you as you bask in the warm glow of success.

It might be tempting to work in isolation and aim to surprise the world when your work is ready. Big names do it all the time, why shouldn't it work for you?

**Don't.**

Before big names reveal their work, many people will have fed back into the process to reduce the risk when the work is released.

Involving others in your journey provides you with a valuable sounding board as you progress. But it also starts building interest in what you are doing, so that when your work is ready you have a room full of people (actual or figurative) interested in the work.

You don't need to show the whole thing; a strategic bit of flesh here and there could be enough to sanity-check your work and evolve it (even if that invites others to disagree with what you're doing!).

## Action:

# BAD IS BETTER

## Someone has done the unthinkable.
## They have DISAGREED with you.

Being told what we don't want to hear is hard but it's often where you'll gather the juiciest insights. To make the most out of this situation, don't get mad, get curious. Next time someone disagrees with you:

1. Give the person your full attention. Focus on capturing as much of the feedback as possible to analyse later.
2. Ask questions to find out why/what they specifically dislike and learn from it.
3. Note things down (or record with permission). You may not remember the subtleties of their opinion.
4. Be calm.* Strong emotions may get in the way of their honesty.
5. Thank them. They invested their time in you.

Managing negative feedback isn't comfortable. Learning to manage your disappointment will unlock opportunities to get more value from the feedback you are given.

*Do your eyes betray you? Pick a bright spot and wear sunglasses.*

The small price to pay for people loving your work is others who don't.

## SWAN LAKE

Being calm isn't always easy; emotions are beautiful and messy.
To get the most honest feedback you need to be like a swan:
a picture of calm above the water while your feet paddle furiously
below the surfaces. Luckily, you have options in how you get
feedback which can help manage the inner emotional storms.

## Pristine lake

**Face-to-face:** The most valuable insights. Seventy per cent of all communication is non-verbal, so it will be easier to read between the lines.

## Feeling breezy

**Video call:** Offers you some of the benefits of seeing the person in front of you but gives you more control over your environment.

## Choppy waters

**Voice call:** Dig deeper into insights on the spot but have cover so others can't read the emotions in your eyes (keep your voice in check!).

## Storm at sea

**Email/recording:** Keep total control over what is sent, but also the slowest way to gather feedback. Sending a video could inspire a similar response, which would give you access to some non-verbal insights.

# CONTROLLED STREAKING

Simply dropping your magnificent project in front of someone and asking them if they like it will lead to any of the following responses:

* OMG! I love it
* It's nice*
* . . . silence

Other than the potential ego boost (which we all need sometimes), you won't learn anything.

Creating something is exciting and you might be tempted to ask for feedback right away. But before you rush in to get a person's view, think about what you will ask them first. Carefully consider what you would like to know before you seek feedback.

Deciding what you want to ask from anyone experiencing your work **in advance** will help unearth richer insights.

*\* Which is like being slapped in the face with a wet fish.*

# DIG DEEPER

How you ask questions is critical in unlocking more interesting feedback.

Think of five questions you would like to ask about one of your ongoing projects (it's perfectly fine if it's still in progress or being planned).

*1.* Write your questions down.

*2.* Answer each question yourself (a quick example of what you think someone will say is fine).

*3.* Then turn this page. No peaking!

Review each question and do the following:

## Step 1

Move questions you've answered with the fewest words to last (e.g. yes/no).

Getting longer answers early allows you to create a deeper conversation which you can explore with more questions on the spot. If all your answers are short, think of more questions to create dialogue.

## Step 2

Asking people to hold lots of information in their heads is a lot of effort and is unlikely to lead to a good answer.

* Was your question more than a sentence?
* Did it secretly hide multiple questions?
* Can you shorten it? Split it?

## Step 3

Questions that begin with 'why' can make people feel like they have to defend an opinion. Convert 'why' questions into 'what' or 'how' questions.

## Step 4

Update your questions, answer any new ones and review them using the first three steps.

Once you are done, these questions will form the basis of a conversation. You will uncover far richer insights by opening up the discussion, steering clear of 'interrogations', and digging deeper into answers.

# TOO MANY COOKS

Someone wants to add more baking soda, another more vinegar, but what you really think your dough needs is to be blended for longer. Following everyone's instructions would lead to some very disappointing cookies (but a very clean blender!).

Do you want to let the public dictate the direction of your work or will you select a few key points to integrate? What do you do with opinions that directly contradict each other? And what if these opinions come from parties that are paying you?

Integrating all the feedback you've gathered could lead to your work losing its sense of direction, style or, worse still, its purpose.

**Feedback is a guide, not an instruction manual.**

Knowing how much you want to keep, what to evolve and what to let go of is an art in itself.

Take a step back when integrating other opinions. Keep an open mind but be critical. Changing the purpose of your work based on others' perception should not be a decision you take lightly.

## Types of feedback

**STYLE**

The word 'deadline' can be quite negative; can we change it?

**TECHNICAL**

You missed a full stop here.

**PURPOSE**

Did you consider this book could be a unicorn colouring book instead?

**EXECUTION**

This chapter is unclear.

## Action:

# FILTER THE BROTH

Having trouble establishing if you should make a change based on feedback? Ask yourself:

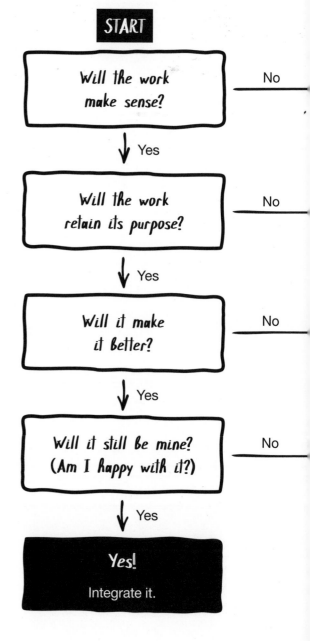

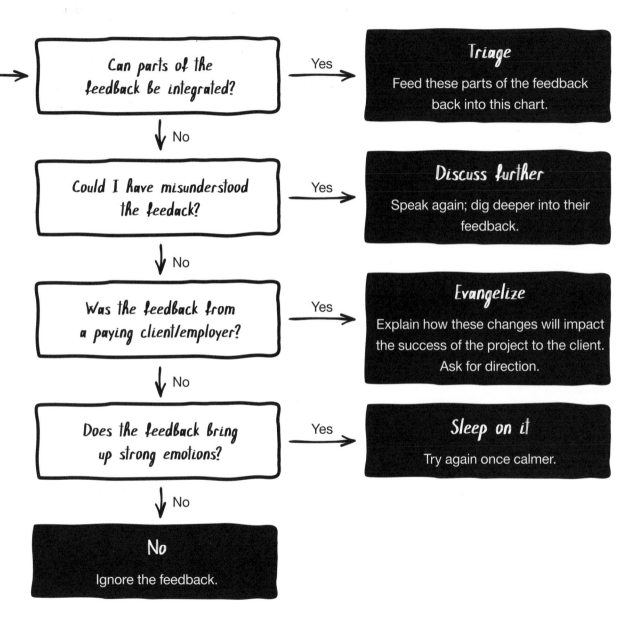

Can parts of the feedback be integrated?

**Yes →** **Triage** — Feed these parts of the feedback back into this chart.

**No ↓**

Could I have misunderstood the feedback?

**Yes →** **Discuss further** — Speak again; dig deeper into their feedback.

**No ↓**

Was the feedback from a paying client/employer?

**Yes →** **Evangelize** — Explain how these changes will impact the success of the project to the client. Ask for direction.

**No ↓**

Does the feedback bring up strong emotions?

**Yes →** **Sleep on it** — Try again once calmer.

**No ↓**

**No** — Ignore the feedback.

# RECAP

1 Who you choose to get feedback from matters. Are you looking to boost your confidence or improve your work?

2 Working in complete isolation for a long time is risky. Try to invite people to sanity-check your progress as you go.

3 Get curious when people disagree with you, as that's where you will gather the juiciest insights.

4 You'll get the most honest feedback when you remain calm and welcome it.

5 Different mediums can help you control strong emotions when gathering feedback (e.g. emails instead of meetings).

# chapter 7

# THE BEGINNING
## TYING UP THE LOOSE ENDS

So far, we've looked at making space in your life for creativity, filling it with inspiration and translating those ideas into reality. We also looked at overcoming challenges faced along the way and refining your work with feedback.

The creative process is expansive. To try to cover it in a book the size of this one is like trying to capture all the stars in the sky and cram them into a pickle jar.*

This book provides you with a rough sketch but, most importantly, it is meant to tickle your curiosity. Make you question, experiment and develop ideas beyond these pages. Although it is impossible for me to cover every question you might have, embracing your own curiosity will allow you to thrive outside the realm of these pages.

In this final chapter, we'll look at tying up some loose ends and cover elements that will allow you to develop your craft into a profession. We'll talk money, marketing and collaboration.

*It looked possible until I tried it.*

# FREE LUNCHES

Some of us don't like talking about money but money is essential.

**Money buys you time to create - without it you'll need to look elsewhere to earn your keep.**

Starting to make money as a creator is challenging. Unlike other industries anchored in the exchange of currency for goods and services, the creative industries seem to defy the laws of capitalism.

> How much? But I thought you would do it for free for the exposure*!

* My mum, a dude called Anton who likes my cat tweets and five bots.

When you start off you may be tempted to give away your work for free to break into the industry. Think carefully before you do so.**

Instead of giving your work away, invoice for the total value of your work, and apply a discount. Although deeply unsexy, invoices:

* Set clear boundaries around what you are giving them, for how much.
* Remind buyers of your true value (makes things easier when you start charging them).
* Ensure clients respect your time (giving a service for free without a clear end means they have no incentive to finish quickly).
* Allow clients to make space for you in their future budgets.

If you feel a need to give your work for free, you can opt for a 100 per cent discount (don't skip invoicing them!). But do so sparingly; with each freebie you hand out, you are reinforcing people's perception of the value of your craft (if it's free now, why should they pay later?).

*** Full disclosure: I am guilty of both giving and accepting work for free; I now know better.*

# YOUR WEIGHT IN GOLD

When you first start out, it can be surprisingly difficult to know the value of your work. In this exercise, we will do a very dirty calculation to establish how much you need to charge to maintain your current lifestyle.

**To maintain your current lifestyle**

$$\text{How much you spent this year} \div \text{No. of hours you worked this year} = \text{Your minimum hourly rate (excluding tax!)}$$

Bank statements will help here

Count five hours per day*

Now you know how much you need to make per hour to maintain your current lifestyle, you can quickly calculate the value of a project. It also allows you to establish how much money you've given away for free.

Converting your time into cold hard cash forces you to think about how that money could support you so that you can continue to create.

*\* You are likely working around eight hours per day. Using five hours allows you to fold your lunch and a few hours of admin into your hourly rate (you wouldn't count them when you quote a client, but they will be reflected in your rate).*

## The small (but mighty) print

This calculation is far from perfect. It is designed as a provocation to make you think about your value and can be refined:

* This is the absolute minimum, it's worth adding a security premium on top of it (build up your savings).

* What you make this year won't be the same as what you need next year. You can rerun the calculation with the income you want next year.

* You won't always be working (be between jobs/unsold work). Using 235 days annually allows for weekend, holidays, sick days, etc.

* Don't forget tax! Multiply your hourly rate by the highest tax rate you will reach (e.g. 1.2 for 20 per cent).

* If you are a big spender, or work very few days a year, your rate may be too high. Make sure to compare your rate to others in your craft.

# ONE'S A CROWD

The media loves to shine a light on creators sitting alone in a room with ideas buzzing around their heads. Focusing on one person as the sole genius behind the work makes telling their story more sensational but it is rarely the case.

**For every individual standing in the spotlight, there are others standing in the shadows.***

Successful creative relationships led to refining Narnia and Middle Earth, inspired Madonna's work ethic, ensured Van Gogh's legacy and galvanised a little-known band called the Beatles.

Each collaboration is a unique blend of traits which support your creative practice. They can be any blend of any of the types shown opposite.

Working alone is fine but finding people you can work with is enriching and (if done right) throws rocket fuel on your creative spark.

*\* They may have their own spotlight on another stage.*

**Muses**
Inspire your work (they need not be naked)

**Editors**
Swap notes with you about your work

**Collaborators**
Work with you on the same 'canvas'

**Patrons**
Provide unwavering support for your work (money, contacts, marketing . . .)

**Mentors**
Teach you the ropes, share notes on your process and practice

**Competitors**
Push you to do better to beat their latest effort

## Action:

# STAIR MASTER

Sometimes the best way to grow is to find someone we admire and seek to build a creative relationship with them. It's simple:

1. Identify someone you want in your creative life (e.g. Mentor, Muse, Collaborator, Patron, Editor, Competitor . . . or a mix of any of them).

2. Approach them for a chat.*

When seeking creative collaborators, don't be tempted to go straight to the top. Start small and level up as you go. This builds your confidence and gives you experience before reaching out to your idols.

To take the pressure off, remember this isn't a lifelong commitment, it's not a date, it's just a conversation. If the conversation goes well then who knows where that will take you.

* If this step made your heart sink, then this exercise was made especially for you.

## MT OLYMPUS
Reach out to
your idols.

0.1% success

## PENTHOUSE
Contact people
who are much more
established than
you.

4% success

## FLOORS 2 UP
Contact people
who are a little more
established than
you.

20% success

## GROUND LEVEL
Contact people at a
similar stage of their
journey to yours.

60% success

## BASEMENT
Start with someone
who knows you.

90% success

141

# TIPS TO INCREASE YOUR CHANCES OF SUCCESS:

## Be brief

No one has time for long messages; three paragraphs is long enough.
A good flow is why you are contacting them, what you need and next steps.

## Be personal

Show them you know who they are. Make it genuine and as specific as possible. 'I love your work' is too generic and shows you made no effort (so why should they?).
*E.g. I've been following your work for a while and was amazed by what you did with . . .*

## Be relevant

If you've seen someone help others and that's what you want from them, be sure to include that. You need to make a case for why you contacted them specifically.
*E.g. As you support emerging talent through your role with . . .*

## Be clear

Make sure those you are contacting know what you want from them (and what's in it for them, if anything). Try to reduce the size of the ask and start small.

*E.g. I was hoping to have a twenty-minute video chat to help me develop my own practice.*

## Be a little persistent

Reaching out to someone once probably won't work but don't spam people either. Contacting people three times is a good amount. The initial approach, a reminder and finally letting them know you realise they are busy and won't try again.

## Be polite

If the response comes back negative, thank them for their time in getting back to you and move on. It's not personal; just like you, they are busy developing their own practice.

## IMPOSTER!

We all have these little voices in our heads telling us that perhaps we're not good enough.

This is what the voices whispered to me writing this book.

| 1 | 2 | 3 | 4 |
|---|---|---|---|
| **I can do this** | **I am doing this** | **This is easy** | **Oh no, I can't, I'm not good enough** |
| Planning this book | Writing chapters 1–5 | Writing chapter 6 | Rewriting chapter 6 |

Having doubts about your own abilities is perfectly natural when you are doing something new. The more ambitious and alien the project is, the louder the voices will become.

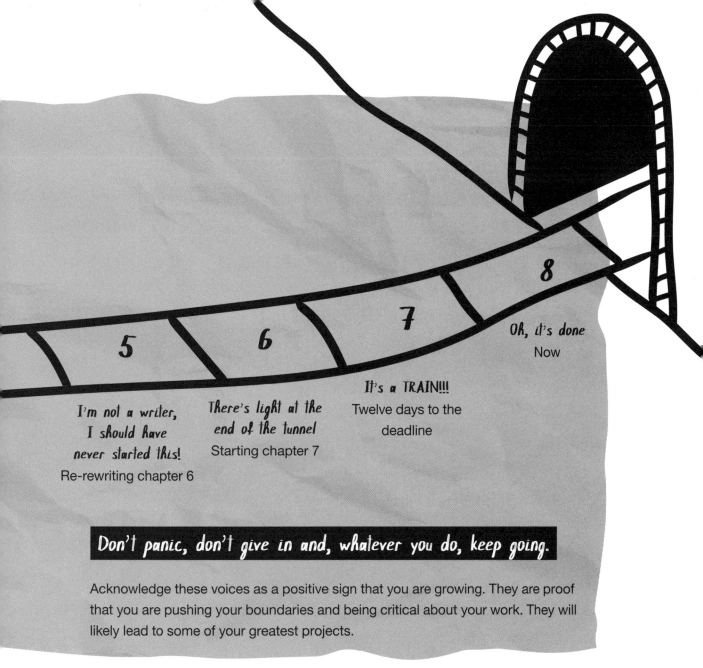

**5**

I'm not a writer,
I should have
never started this!
Re-rewriting chapter 6

**6**

There's light at the
end of the tunnel
Starting chapter 7

**7**

It's a TRAIN!!!
Twelve days to the
deadline

**8**

OK, it's done
Now

**Don't panic, don't give in and, whatever you do, keep going.**

Acknowledge these voices as a positive sign that you are growing. They are proof that you are pushing your boundaries and being critical about your work. They will likely lead to some of your greatest projects.

# BE A PERSON

Getting attention has become a battlefield. Everyone is competing for our audiences to sell their wares. You may not have the budgets and dedicated marketing departments others have, but you have something businesses don't:

**An authentic personal story.**

You can share your story in any medium, strike up a conversation with someone at a café, post on Twitter, present on a stage at a conference, in an email . . .

Telling your story creates curiosity and empathy with your audience. It makes people aware of how much work goes into what you do, which in turn makes a case for your prices.

Although the digital world has pivoted from serving us (allowing us to create exposure to our work) to 'serving us' (on a plate with a slice of lemon as a product for sale to advertisers), sharing our stories online is still valuable. But posting content and expecting someone to care is akin to standing around at a busy train station mumbling to yourself. It won't magically get you noticed without some effort.

# TIPS ON BEING HUMAN ONLINE

The best way of being seen and remembered in any of the spaces is to create meaningful dialogue with the people in those spaces. Add value ('You like turnips? You might like this picture of this odd-shaped one'), be curious about their journeys and contribute your thoughts. If there's interest in your work, develop it and inspire others to share it.

And remember, the relationships we have are not with our phones but with the people who inhabit them.

**People love people.**

How you share your work matters.

When people engage with you, you want to maximize the chances of them taking an interest in your work and following you.

* Think carefully about what is interesting, unique, and fun about your work/process. Share that.

* When presenting imagery, make sure the quality reflects that of the work. No badly cropped, blurry photos. Light your work properly and keep backgrounds unintrusive.

* Say no to avalanches of cat photos and vegan bacon sandwiches – people might engage with those but does it really develop your craft? (If bacon is your medium, go right ahead.)

* Share the challenges of your craft, but stay clear of complaining.

* Engage with others on the network. Social media has the word 'social' in it; it's not just for humble bragging.

## Action:

# ROLL THE DICE

Social media is a slow burn. By doing small actions every day and engaging meaningfully with others, you will naturally grow your audience and create valuable relationships.

Others might tell you to spend weeks on planning your content, but that might put you off. Instead you could just chance it.

1. Get two dice and place them on your desk
2. Roll them every day
3. Add the values on both dice
4. Spend 15 minutes on the associated action below. If you roll a double (e.g. 4–4) do both the action and the bonus double.

**Roll 2** Review your account. Improve your description and banner imagery.

**Roll 3** Follow the personal accounts of three people who work at organizations that you admire.

**Roll 4** Re-share someone's work with a meaningful positive commentary.

**Roll 5** Follow three people who will enrich your feed with good content.

**Roll 6** Share something about your work (no pets, no food!).

**Roll 7** Respond to any messages you've received. Thank people for tags.

**Roll 8** Share something about your creative journey (no pets, no food!).

**Roll 9** Tag someone on a post you think they would like (not one of yours).

**Roll 10** Follow five people who follow people like you. Choose the interesting ones!

**Roll 11** Unfollow five accounts that don't add anything meaningful to your feed (dead accounts).

**Roll 12** Shameless plug! Ask someone you know to share your work to their own network.

**BONUS double** Find a post relating to a theme in your work. Respond with a meaningful comment linking to a few relevant works and **include your own**.

## If getting physical is more your thing

* Use only 1 die.
* Roll it every month, or every two weeks, if you're keen.
  (These actions are likely to take you a few hours to undertake.)

**Roll 1**    Sign up to and attend an event (conference, industry talk). Try to strike up a conversation with at least three people you don't know at the event.

**Roll 2**    Identify a competition/award/open exhibition you want to submit to. Add it to your calendar and submit once it opens.

**Roll 3**    Reach out to someone you know and organize to meet. Remember this needs to serve you in creating exposure to your work.

**Roll 4**    Ask someone you know to introduce you to someone you don't know (who you might find interesting) to have coffee.

**Roll 5**    Go to an exhibition/screening/shop which attracts people who might have an interest in what you do. Try to strike up a conversation with someone you don't know.

**Roll 6**    Sign up for an industry speed dating event (could be online).

# IGNORE ME

You can breathe a sigh of relief. This is the last section.

What a ride!

We banished your digital demons. You've had tea with death. Your diet of experiences has been challenged. We've raised dead(lines). I've stripped you bare in front of others, sat you in a cardboard box and I may have made you pretend to be a flamingo in your living room.

This is the perfect time to thank you for investing your precious time in reading my work and to shamelessly mention the fact that a review/feedback are very much appreciated. **But please, please, please do so before moving to the next page**, since I think that might impact your views!

As you've come this far,

you deserve to know that . . .

. . . No book will make you creative.

Only you can do that (sorry!).

We all experience creativity differently. Writing about such a personal process and expecting every page to be relevant to you pushes even my plucky optimism to the extreme.

This book is a tiny part of a much larger puzzle that is unique to you. The pieces are in front of you and it's your responsibility to put them together in whichever manner works for you.

Some of what I have written will work, some of it won't. Take what works, bin what doesn't, but whatever you do, **never stop believing** in your ability to create.

STILL HERE?

Stop reading me.

Go create something gre . . . !*

*And remember, nothing is ever fini . . .*

# RECAP

*1*   Don't give away your work for free, give people discounts. This ensures they know what your real value is.

*2*   Calculating the value of the work you are doing can help you make better decisions, even if the work isn't being paid for.

*3*   When you push your boundaries into more ambitious projects, it's only natural to doubt your abilities. Acknowledge the voices and continue creating.

*4*   No matter the medium you choose to create exposure, remember that the best way to get people's attention is by engaging meaningfully with them.

*5*   No book can make you creative, only you can do that.

*6*   Take what works, bin what doesn't, but never stop believing in your own creativity.

# ABOUT THE AUTHOR

Guy Armitage has worn many hats (some quite badly). Through his diverse experiences he has evolved to fuse creativity, technology and business.

Guy hopes to unlock opportunities in the creative sector by simplifying the process of running calls to submissions through Zealous (https://zealous.co).

Prior to Zealous, Guy kept the London Stock Exchange open during the 7/7 bombings, founded a start-up in Egypt and studied artificial intelligence (it was so uncool at the time).

He was voted the Guardian's Hospital Club Creative Entrepreneur of the Year in 2013, has discussed the potential of creativity at conferences and in *Forbes*, is a trustee of Firstsite (voted Art Fund Museum of the Year in 2021) and is chair of digital art gallery arebyte. To scratch his creative itch he has made (a single piece of) digital art, which won the Tate Modern Hackathon in partnership with Ai WeiWei, takes still photos, has written and directed a (single) short film entitled *Tech Support* (which won no awards) and has featured (for a whopping six seconds) in *Soulmate*, a film directed by Axelle Carolyn.